KU-244-431

Victorian Art

Susie Hodge

First published in Great Britain by Heinemann Library
Halley Court, Jordan Hill, Oxford OX2 8EJ
a division of Reed Educational and Professional Publishing Ltd

OXFORD FLORENCE PRAGUE MADRID ATHENS
MELBOURNE AUCKLAND KUALA LUMPUR SINGAPORE TOKYO
IBADAN NAIROBI KAMPALA JOHANNESBURG GABORONE
PORTSMOUTH NH CHICAGO MEXICO CITY SAO PAULO

© Reed Educational and Professional Publishing Ltd 1997

All rights reserved. No part of this publication may be reproduced, stored in a retrieval system, or transmitted in any form or by any means, electronic, mechanical, photocopying, recording, or otherwise without the prior written permission of the publishers or a licence permitting restricted copying in the United Kingdom issued by the Copyright Licencing Agency Ltd, 90 Tottenham Court Road, London W1P 9HE

Produced by Plum Creative
Illustrations by Oxford Illustrators
Printed in Malaysia

01 00 99 98 97
10 9 8 7 6 5 4 3 2 1

ISBN 0 431 05624 2

DUDLEY PUBLIC LIBRARIES

L 44358

601217 SCH

J942.081

British Library Cataloguing in Publication Data
Hodge, Susie
 Victorian art. – (Art in history)
 1. Art, British – Juvenile literature 2. Art, Modern – 19th century –
 Great Britain – Juvenile literature
 I. Title
 709.4'1'09034

Acknowledgements

The Bridgeman Art Library: Bonhams p6, Elida Gibbs Collection p28, Fine Art Society p19, Freer Gallery, Smithsonian Institute, Washington p21, Guildhall Library p26, Lady Lever Art Gallery p5, Museum of London p29, Royal Holloway and Bedford New College p10, Stapleton Collection p17, Tate Gallery pp14-15; Cambridge Fine Art p13; Mary Evans Picture Library p24; A F Kersting pp 22,25; Leeds Museum and Galleries, (City Art Gallery) p4; Mackintosh Collection, Glasgow School of Art p27; William Morris Gallery p20; MSI p23; National Gallery p12; Private Collection p7; The Royal Collection © Her Majesty the Queen pp8-9; Royal Photographic Society p16; Trustees of the V & A pp11, 18.

Cover photograph reproduced with permission of A. Pope Family Trust, Bridgeman Art Library. Our thanks to Paul Flux and Jane Shuter for their comments in the preparation of this book. Every effort to contact copyright holders of any material reproduced in this book. Any omissions will be rectified in subsequent printings if notice is given to the Publisher.

Cover Picture:
Private View at the Royal Academy, 1883, William Powell Frith (1819–1909),
102.9 x 195.6 cm, oil on canvas
The Royal Academy was the most important art gallery for Victorian artists. Every year, it held an exhibition of artists' work. All the people in this painting were famous Victorians – writers, poets, artists, lords, ladies, actresses and politicians. Frith made many sketches of the people before painting the picture. He could never have got all the things he wanted to show together at any one time. He also wanted to show the ladies' fashions – there was a new craze of flowing dresses that some ladies thought were far more artistic than the usual stiffer, fancier fashions. Can you see which they are? A rail was put up to protect this painting when it was exhibited – a sign that it is one of the most popular paintings that year.

CONTENTS

WHAT WAS VICTORIAN ART?

Queen Victoria ruled Great Britain for 64 years from 1837–1901, the longest reign in British history. It was a time of new ideas, inventions and discoveries. Many of these had a big impact on the art of the time.

Artists everywhere

Victorian artists tried out new ways of working and produced vast numbers of paintings, prints, sculpture, photographs and buildings. Their art shows us many things, such as the clothes Victorian people wore, how they worked, how they viewed life and what they thought of themselves.

Art galleries

Before the Victorian age, there were no public art galleries in Britain. The National Gallery in London opened in 1838, and soon museums and art galleries had opened all over the world. For the first time, the public could see works of art close-up.

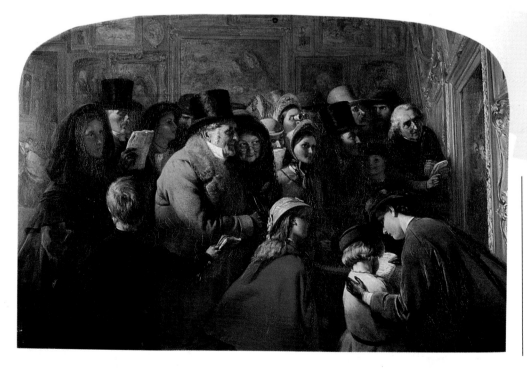

Public Opinion, 1863, George Bernard O'Neill (1828–1917), 53.4 x 78.7 cm, oil on canvas.

This painting shows eager Victorian visitors gathering at the annual Royal Academy art exhibition. A rail protects the most popular pictures.

Inventions and discoveries

New inventions, such as telephones, railways and factories, were changing the way people lived. The invention of photography in 1839 particularly affected the artists. Some artists used photographs to help them with their painting. Others tried to make their paintings look like photographs.

Photography made people think again about the job of an artist. If the camera could make an instant picture, why should an artist do the same?

Artists began experimenting by trying out new materials and designs. Even **architects**, who had to design new railway stations and exhibition halls, used new materials and tried new ideas.

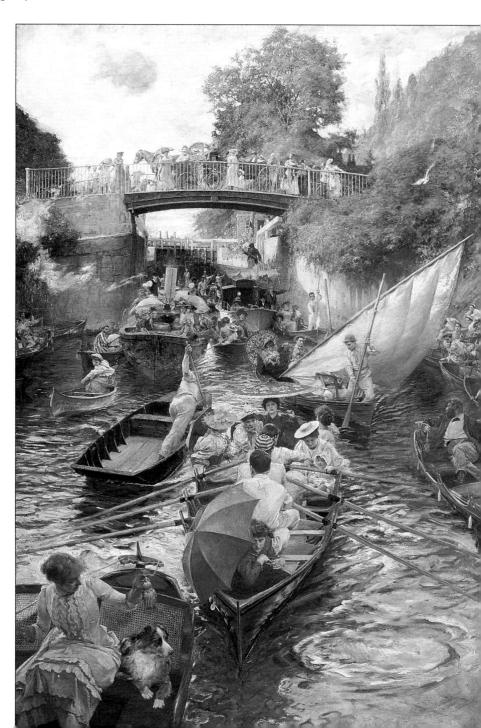

Boulter's Lock – Sunday Afternoon, 1897, Edward John Gregory (1850–1909), 214.6 x 142.8 cm, oil on canvas.

*This painting of Londoners boating on the Thames was shown at the Royal Academy in 1898. Many of the people who came to the exhibition thought it was interesting and lively. Each group of people in the painting has its own story. Gregory worked for years on the picture, making **oil sketches** of practically every figure before finishing the painting. Yet it still looks fresh.*

MATERIALS AND METHODS

Few artists became rich. Many taught art privately to earn money, while new methods of cheap printing gave some the chance to work on **illustrations** for books and magazines.

New art schools were opening all over the world. The Royal Academy in London was the most important in Britain. Artists trained at its schools, and exhibitions were held there. After artists had completed their training, they usually worked in their own studio. Their works were commissioned (ordered) or they painted what they wished.

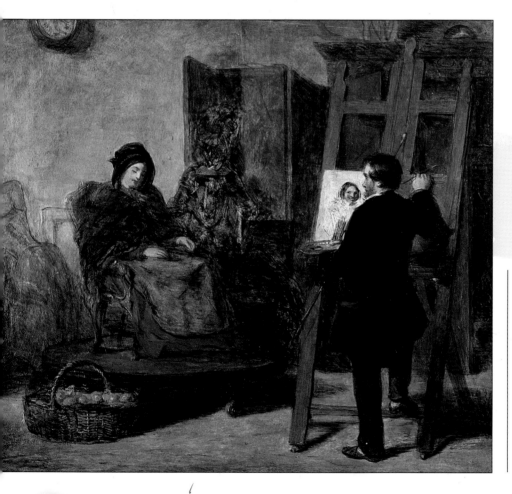

The Sleepy Model, 1853, William Powell Frith (1819–1909), 63.5 x 71.4 cm, oil on canvas.

This is a self-portrait of the artist painting a model in his studio. Frith was not commissioned to paint this. He persuaded an orange-seller to sit for him by buying all her oranges!

Roses and Pinks, Levens Hall,
Westmorland, 1892,
George Samuel Elgood (1851–1943),
31.8 x 49.5 cm, watercolour.

Artists now had better paints. Elgood included this bright watercolour in a book about English gardens. It has a feeling of fresh daylight; the colours are rich, yet natural.

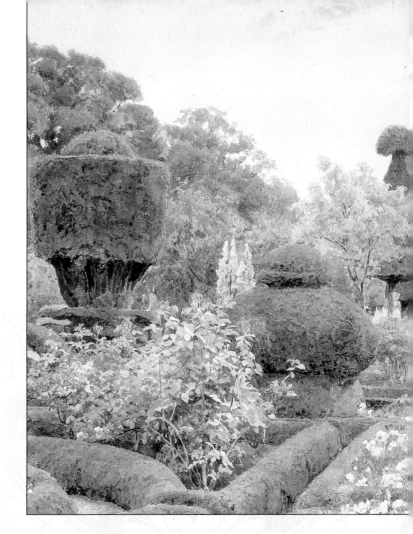

How paints were made

Painters used mainly **watercolours** and **oil paints**. Watercolours had been used since the late 1700s. They produced delicate, light-filled paintings. Watercolours were made of a mixture of **pigments**, **gum** and **glycerine**. The mixture was hardened and then cut into small cubes. As watercolours could be carried easily on painting expeditions, they had an advantage over early oil paints.

To make oil paints, pigments were mixed with oil. At first artists had to mix their oil paints themselves which meant the paints were awkward to transport. But by the late 1800s, oil paints were sold ready mixed in tubes and became easier to carry. Oils were also slow-drying, so artists could correct mistakes.

Artists' palette

New chemical and dyeing techniques meant that Victorian painters had an explosion of new colours to use. Red came from ground rocks, yellow and blue from chemicals such as sulphur, and green came from mixtures of blues and yellows. Mauve came from coal-tar, black from charcoal, brown from earth and white from chalk.

PORTRAIT OF A QUEEN

There were many **portraits** painted of Queen Victoria. By looking at them we can follow the events of her life and the changing fashions of the time. People bought pictures and small pottery statues of their queen and some even wore miniatures (very small portraits) of her as jewellery.

Victoria Regina, 1887, Henry Tanworth Wells (1828–1903), 122.6 x 165.7 cm, oil on canvas.

This is one artist's version of the moment when 18 year old Victoria was told that she was queen. The early morning light fills the room (it was 6 am). The kneeling men are the Archbishop of Canterbury and a lord. They are kissing her hand to show that she is now their ruler. This was not painted at the time — it was painted 50 years after the event! The artist has used his imagination and made the picture romantic, like a page out of a storybook.

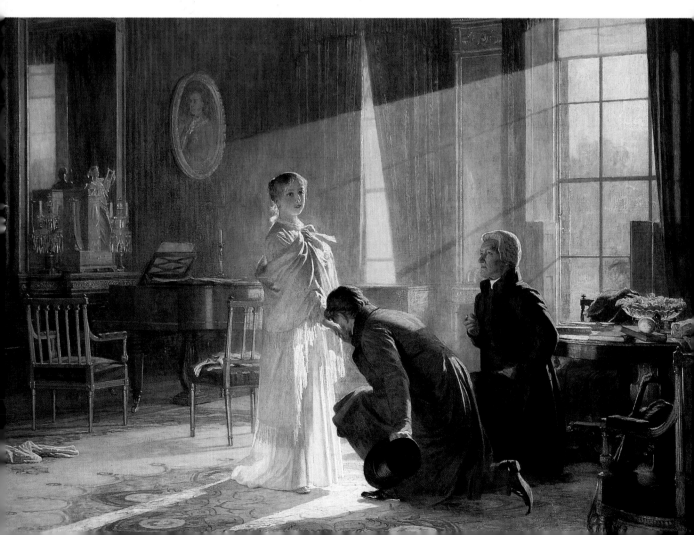

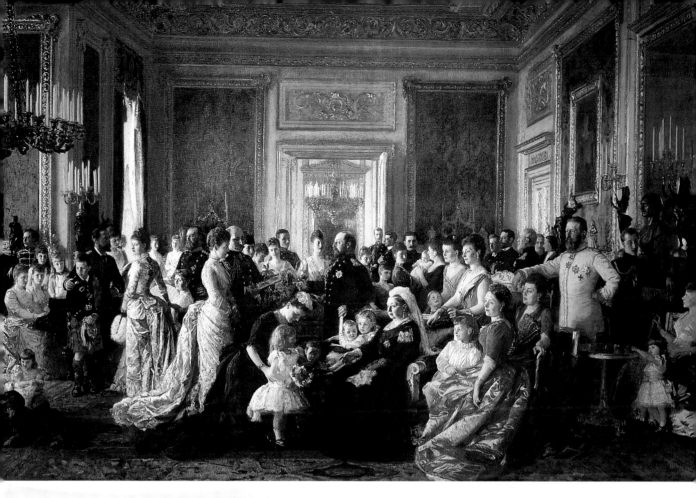

The Family of Queen Victoria, 1887,
Laurets Regner Tuxen (1853–1927),
165.7 x 226.1 cm, oil on canvas.

Can you see Queen Victoria? This portrait was
painted for her when she was celebrating 50 years
of being queen. She was 68 years old and is
surrounded by her children and grandchildren.
The painting is like a photograph.

Tuxen had to arrange the **composition** *carefully,*
so as not to offend anyone. The Prince of Wales,
the queen's eldest son, is standing beside her in the
centre of the picture, and two of her daughters,
Princess Victoria and Princess Helena, are sitting
nearby. Queen Victoria thought this painting was
'prettily grouped'. Compare the ladies' clothes and
hairstyles to the painting on page 11. See how
differently poor people were dressed during
Victorian times.

Natural paintings

An artist who created realistic
portraits of the queen was Sir
Edwin Landseer (1802–73).
He was actually an animal artist
and had some difficulty with
human portraits. But his paintings
of Victoria seem natural and
relaxed.

Pleasing the queen

Portraits like these were painted
to please the queen. In the first,
she looks young, brave and
beautiful. In the second, she looks
quietly powerful, loved by her
family and the court who
surround her.

PEOPLE IN PICTURES

Before Victorian times most paintings were bought only by rich and important people. But this changed as people flocked to the new art galleries and more people bought paintings to put in their homes. As artists competed with each other for work they developed new styles.

Clean dirt

Most Victorian painters took care to avoid details that might offend others. For example, in Victorian times, dirt was everywhere – on the streets, on women's long sweeping skirts and puffing out of steam trains – but it was rarely in paintings.

Modern-life paintings

Paintings now had to be understood and enjoyed by people from all sorts of backgrounds. So artists began to paint ordinary people and everyday activities. Their paintings looked like snapshots of real life. They were called **genre** paintings. Narrative paintings, which told stories, were also popular. Both styles included lots of detail.

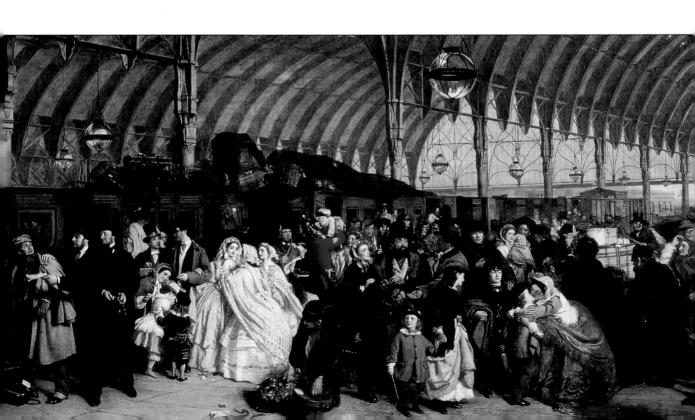

Not the whole truth

Artists also had to be careful not to paint poverty or sickness too realistically. For example, there were many scenes painted of poor and down-and-out people. But the adults are not shown to be too thin, sick or ugly. Their babies are chubby and there is no dirt to be seen. After all, art was intended to be enjoyed, so realism could only go so far.

The Railway Station, 1862, William Powell Frith (1819–1909), 115.5 x 244.6 cm, oil on canvas.

*This narrative painting shows Paddington Station in London. Black smoke would have billowed out of these trains, but it is not shown here. Frith used models, photographs and sketches to create the painting, including plenty of information about Victorian life. Both poor and wealthy families jostle past each other, a soldier kisses his baby goodbye, there is an arrest and a wedding party. The public loved Frith's modern-life paintings, but **critics** and other artists thought they were ugly.*

The Poor, the Poor Man's Friend, 1867, Thomas Faed (1826–1900) 40.4 x 61 cm, oil on canvas.

This genre painting is typical of the way some Victorian artists showed poor people – relaxed, happy and generously giving away some money to a passing blind beggar. Everyone in the picture seems respectable, clean and well fed. Just what people wanted to see!

LANDSCAPE PAINTING

Landscapes were once seen as just backgrounds to paintings. But by Victorian times they were popular in their own right. One artist painted such landscapes as had never been seen before. He was Joseph Turner. Some called him the 'master of coloured light.'

Rain, Steam and Speed – The Great Western Railway, 1844, Joseph M. W. Turner (1775–1851), 91 x 122 cm, oil on canvas.

Turner captured movement and mood. He did not include many details. Steam and mist swirl around the train in scraped-on thick, crusty paint. Details of the speeding train are shown with thinner paint. His style of capturing a moment influenced many other artists, particularly some French painters called **Impressionists***. Some people consider Turner to be one of England's greatest artists.*

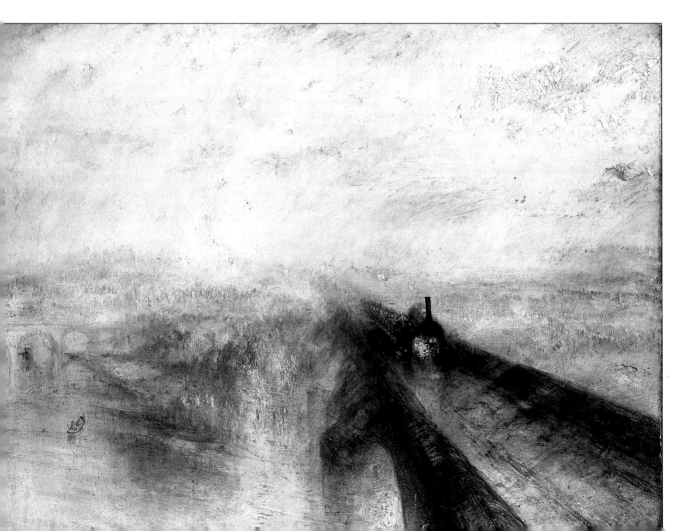

Commoners, 1875, William H. Hopkins (about 1830–92),
50 x 75 cm, oil on canvas.

Joseph Mallord William Turner (1775–1851)

Turner was born in London, the son of a barber. At fourteen, he entered the Royal Academy and also studied with a watercolourist, Thomas Malton.

In about 1794 Turner began working for an art collector, Dr Monroe, copying drawings by J. R. Cousins. He became fascinated with how to paint the effects of light, weather and atmosphere.

Turner exhibited his first painting at the Royal Academy in 1796. It was a great success. Later he travelled to France, Switzerland and Italy, returning with sketchbooks full of **watercolour** views of foreign scenes. In his studio he turned these into huge paintings. He became famous for his landscapes in **oils** and watercolour. His favourite subjects were sea, storms, sunrise and sunset. Turner died in London at the age of 76.

*The **composition** leads you straight into the picture's scene. Like most Victorian painters, Hopkins made sketches on the spot, combining them in his final painting. He was careful to follow natural daylight colours. His landscapes often included some people and animals for extra interest.*

Peaceful pictures

Turner's work fascinated many people with its vivid colours and mysterious effects. But many artists still preferred to paint gentler views of the English countryside. Their paintings showed more relaxed scenes from the days when there were fewer machines.

THE PRE-RAPHAELITES

In the 1840s some young artists were unhappy with the style of art that was being taught at important art schools like the Royal Academy. Art teaching followed the traditions of the 15th-century artist, Raphael. This style made everything look perfect. The young artists thought this was dishonest. They preferred paintings from before Raphael's time, when artists tried to copy nature as it really was.

Secret society

The unhappy artists created a secret society, calling themselves the Pre-Raphaelite Brotherhood (Pre-Raphaelite means 'before-Raphael'). In 1848 they showed several paintings at the Royal Academy, signed with the initials P.R.B.

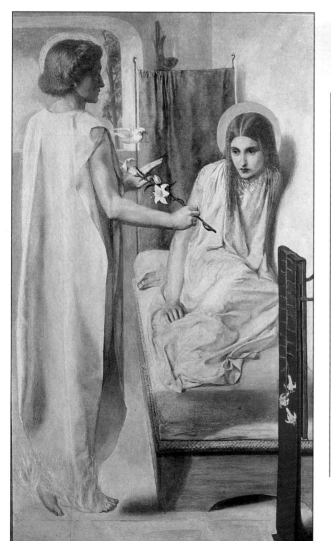

The Annunciation: Ecce Ancilla Domini, 1849–50, Dante Gabriel Rossetti (1828–82), 72 x 42.5 cm, oil on canvas.

The fire-footed Angel Gabriel appears to the sleepy Virgin Mary. Mary looks like an ordinary, frightened girl. White was used to symbolize purity.

*Art **critics** were horrified because the paintings showed religious characters as ordinary people in humble surroundings. This was not what they expected. But it was the Pre-Raphaelites' main point. They believed that art should show serious subjects, like stories from the Bible, poetry or legends, but be true to life.*

The Pre-Raphaelites discussed and wrote down their ideas about which artists and famous people they admired. Their paintings were as accurate as possible and based on detailed studies.

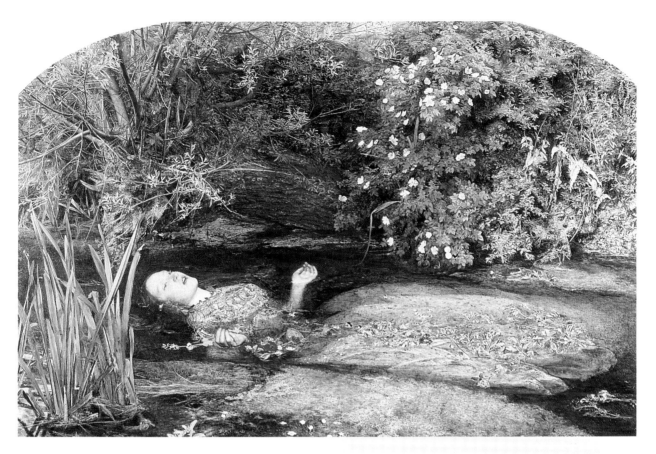

Bright colours

The Pre-Raphaelites used bright colours over wet, white backgrounds. This made their paintings look fresher than other Victorian paintings, which were usually painted on brown backgrounds. But still, many people hated their work. Charles Dickens wrote angry articles about the artists, and the Brotherhood broke up within five years. But they continued painting in their striking way and other artists took up their style. The Pre-Raphaelite style continued throughout Queen Victoria's reign.

Ophelia, 1852, John Everett Millais (1829–96), 76.2 x 112 cm, oil on canvas.

This painting is jewel bright. The story of the drowned girl came from a play by Shakespeare, who the P.R.B. greatly admired. Rossetti's future wife, Elizabeth Siddal, posed for the painting by lying fully dressed in a bath of water. The water was kept warm with lamps burning underneath, but she still caught a cold!

Members of the P.R.B.

The original members were painters called:
John Everett Millais (1829–96)
William Holman Hunt (1827–1910)
Dante Gabriel Rossetti (1828–82)
James Collinson (1825–81).
The art critics William Michael Rossetti and Frederick Stephens, and the sculptor Thomas Woolner also joined.

PHOTOGRAPHY

From the 1840s, for the first time, it was possible to make completely accurate pictures without drawing or painting them. When photography was invented, some artists suddenly felt unwanted. The painter Paul Delaroche is said to have announced what many people were thinking: 'From today, painting is dead!' Other artists later found that photography could be a useful tool.

How portrait photographs were taken

People having their photographs taken had to sit rigidly in the same position for a long time. Sometimes they even had their necks clamped to help keep them still. Any movement would ruin the picture. No wonder Victorians rarely smiled for the photographer.

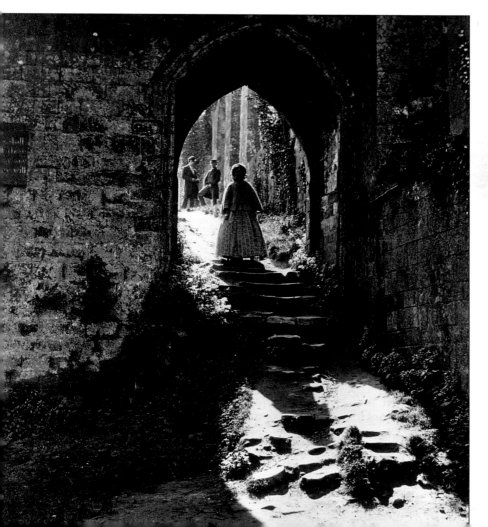

Vista, Furness Abbey, 1860, Roger Fenton (1819 – 69), photograph.

Roger Fenton took photographs of people, landscapes, buildings and war. The public found them fascinating. This view captures dramatic light effects made by the sun shining through the stone archway, as the woman passes through.

The first photographers

In 1826, a Frenchman, Joseph Niépce, discovered how to fix images on to a metal plate. Each picture took eight hours to develop! Another Frenchman, Jacques Daguerre, invented the daguerrotype, a picture printed on metal, in 1835. In 1839, An Englishman, William Henry Fox Talbot, discovered how to print photographs on paper.

Many artists changed their art studios into photographic studios and people flocked to have their pictures taken. The best photographic studios were at the top of buildings where there was plenty of light. Most photographers took portraits, but some took city views and **landscapes**. Colour photographs were not possible until 1891.

An unexpected discovery

The Englishman, Eadweard Muybridge, took the first real action photographs. Using special equipment and several cameras, he took sequence (several, one after the other) photographs of animals as they moved.

Horse Galloping, 1887, Eadweard Muybridge (1830–1904), photograph.

Muybridge featured many animals in his book, Animals in Motion. The photographs must have been fascinating to the Victorians, who had never seen moving pictures. His photographs showed that artists had been wrong to paint galloping horses with all four legs sticking out like rocking horses.

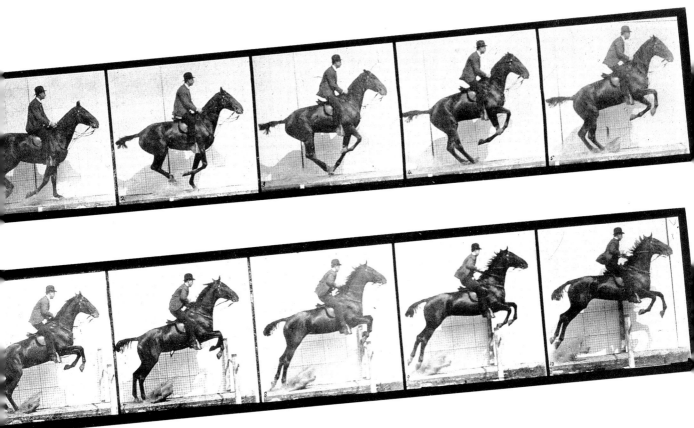

ARTS AND CRAFTS

During the 1800s machines were invented to do jobs faster and cheaper than people. Goods were **mass produced**. Some artists believed that these goods were poorly made and designed. These artists formed the Arts and Crafts movement.

Art of the past

The movement was led by the artist, designer and writer William Morris. Artists who joined him were against poor standards of work and the over fussy designs that were being used. Arts and Crafts designers worked together in **guilds**, just as artists had done in the **Middle Ages**, over 500 years earlier. They used designs from that time, too.

William Morris (1834–96)

William Morris moved to Oxford to train as a priest, but went on to study architecture, art and poetry. In 1861 he started a company that produced hand made furniture, stained glass, carpets, **tapestries**, fabrics and wallpapers. He was dedicated to raising standards of work. He learned every technique of the arts so that he could successfully design for them.

Morris also gave lectures on craft skills and used his own printing press to make beautifully designed and produced books. When he died at only 62 years old, his doctor said that he died of 'simply being William Morris and having done the work of ten men'.

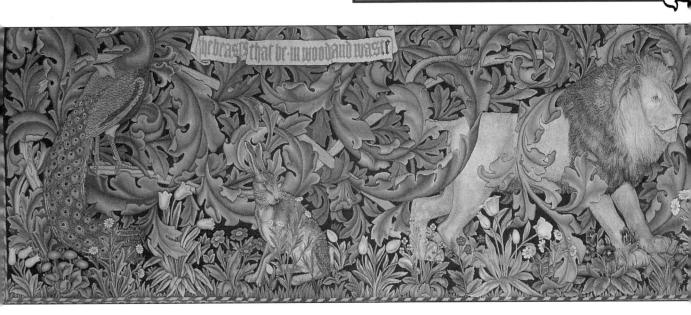

An Arts and Crafts interior, William Morris and William de Morgan (1839–1917) designed and made by them in about 1888.

William de Morgan was a pottery designer who worked with Morris for a while. The wallpaper, called 'Peacock and Dragon', shows the same flat-but-curly stylized patterns. The tiles, pottery, carpet and furniture were all designed by those artists who believed that the machine age was ruining design skills and quality. Arts and Crafts artists and designers got their ideas from medieval history, nature and exotic oriental styles.

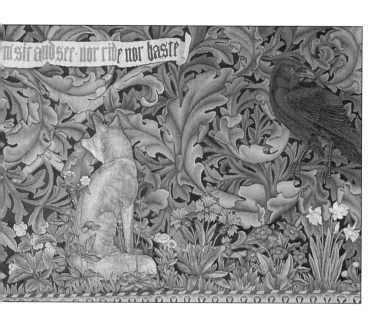

The Forest Tapestry, 1887, William Morris (1834–96), Philip Webb (1831–1915) and John Dearle (1860–1933), tapestry.

This tapestry was made by Morris and his two friends. The leaves are copies of real acanthus leaves, but **stylized** to look like flat, curling patterns. Webb, who was an **architect**, designed the animals and Dearle designed the flowers.

ART NOUVEAU

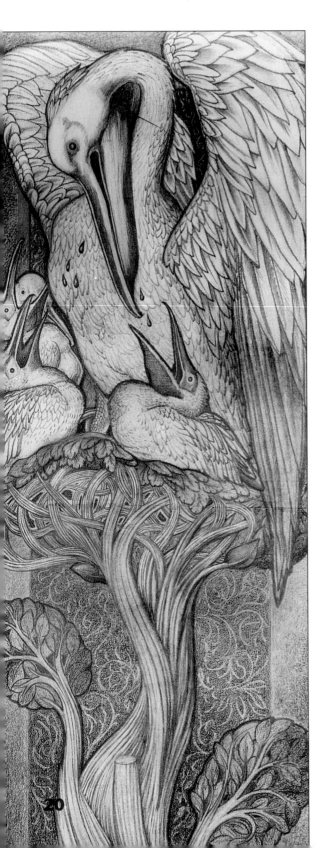

In the late 1800s many artists and designers wanted a new style of art, using new types of materials, to welcome in the new century. They believed that the design of everything mattered, for example, a table lamp deserved as much attention as a statue.

A new style

Designers mixed the natural flowing forms of the Arts and Crafts movement, the freshness of the Pre-Raphaelites and the **asymmetrical** Japanese styles that were becoming popular. The result was Art Nouveau, which is French for 'New Art'. It broke away from accepted Victorian art and design, and spread rapidly across Europe and America. Through magazines, shops and exhibitions, artists and designers exchanged ideas about the new style.

The Pelican, about 1880, Edward Burne–Jones, (1833–98), 172.7 x 57.3 cm, pastels.

This drawing was a pattern for a stained glass window. The flowing asymmetrical forms were inspired by the Arts and Crafts movement and Japanese prints. Burne-Jones' use of elongated shapes made him a natural Art Nouveau artist. He was also involved with both the Arts and Crafts movement and the Pre-Raphaelites.

New attitudes

Art Nouveau inspired artists to experiment with **composition**, brushwork and more imaginative subjects. The American artist James Abbott McNeil Whistler, who settled in London in 1859, believed that painting should flow like music. Using soft, loose brushstrokes, and concentrating on shape, colour and pattern, he simplified and flattened the subjects in his paintings. He used cool, clear colours and gave many paintings musical titles, like *Symphony*, *Arrangement* or *Nocturne*.

Nocturne in Blue and Gold: Valparaiso, 1866, J. A. N. Whistler (1834 - 1903), oil on wood.

Using few colours and thinned paint, Whistler's free, decorative designs are almost abstract. The art critic, John Ruskin, declared that Whistler was 'flinging a pot of paint in the public's face.' Whistler took Ruskin to court and won the case, but legal costs made him bankrupt.

A style for everything

Art Nouveau artists applied the style to everything, from posters, lamps, vases, glass and ornaments to jewellery, clothes, furniture and architecture. Avoiding straight lines, designers made flowing, curving patterns out of plants, flowers, insects, female faces and hair. Art Nouveau suited everything, from small brooches to vast buildings.

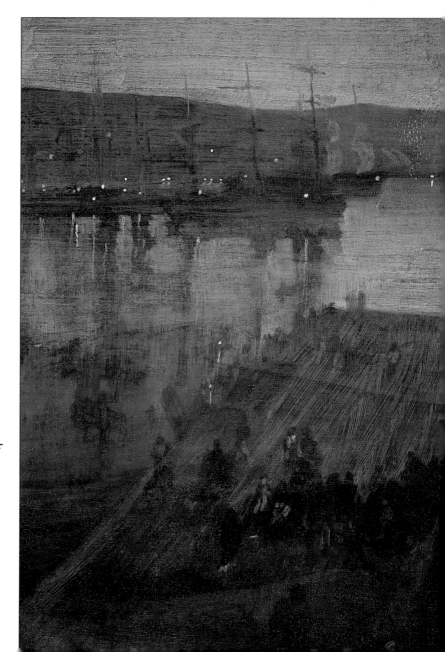

VICTORIAN SCULPTURE

There was so much happening in painting, **illustration**, design and architecture during the Victorian period that sculpture can be forgotten. Victorian sculpture was mainly statues, both large and small.

Poor sculptors

If sculptors were not commissioned, they made sculptures in **plaster** or clay and hoped that someone would buy them. Wealthy **patrons** might then pay for their clay or plaster works to be cast in **bronze** or **marble**. Sculptors could not afford better materials on their own. But their sculptures were not always bought and many that stayed as plaster or clay have disappeared. Boudicca (below) was not cast in bronze until 1897, 41 years after it was started.

Boudicca, 1856 (cast 1897), Thomas Thornycroft (1815–85), bronze.

Boudicca was a Celtic queen who fought the Romans. This statue was designed to make people think of Victoria as a warrior queen at a time when her army was often at war. The statue took Thornycroft fifteen years to make.

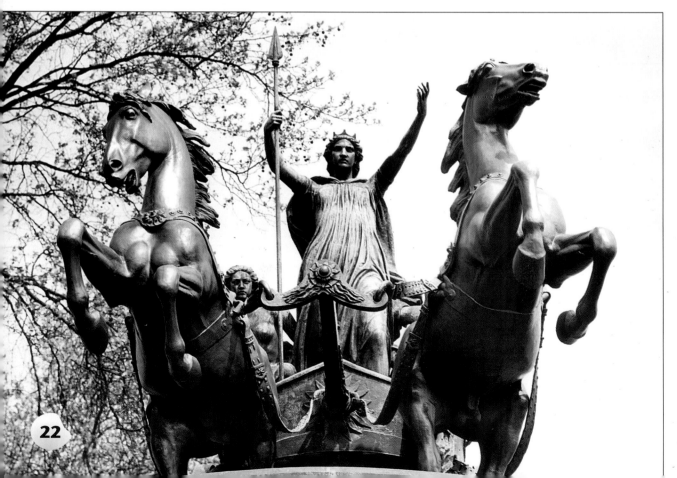

How sculptures were made

1 The sculptor made many drawings and a small model before starting on the full scale work.

2 The sculptor modelled the full sized work in clay or plaster.

3 The assistants **cast** a plaster model around the clay model.

4 When the cast dried, it was cut in half and taken off the clay model. The plaster cast was then fixed back together and coated inside with **zinc**. Liquid plaster was poured in.

5 When the liquid plaster dried, the outer cast was removed, and could be used again.

Detail from the Albert Memorial, London, 1863–76, designed by George Gilbert Scott (1811–78), granite, bronze, gilt and marble.

Queen Victoria had this built in memory of her beloved husband Albert. A huge **gilt-bronze** *statue of Prince Albert stands in the centre, beneath a richly decorated canopy. The Prince is surrounded by sculptures of the arts, sciences and other projects that interested him. It shows how much Victoria loved Albert. It also emphasises the parts of his life that were seen as important in contributing to the British Empire.*

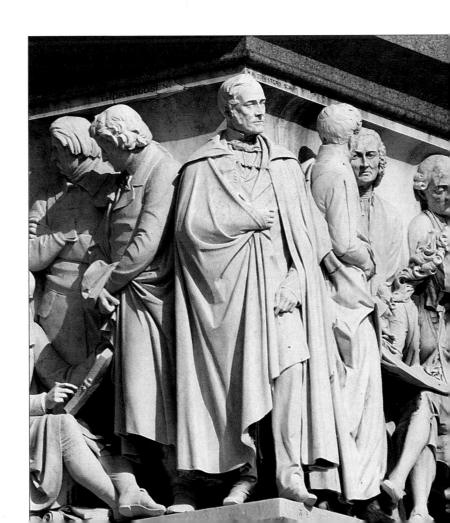

VICTORIAN BUILDINGS

Many buildings were constructed during the Victorian period. They ranged from homes for the growing population to grand museums, stations and other public buildings. Styles of architecture varied widely, depending on what the building was used for and how much was being spent on it.

Space and light

In the **Middle Ages**, abbeys and cathedrals were built in the Gothic style, with pointed arches that gave the feeling of soaring space and light. They often featured detailed decorations and stained glass.
A. W. N. Pugin used similar designs in the 1880s. It became known as the 'Gothic Revival'.

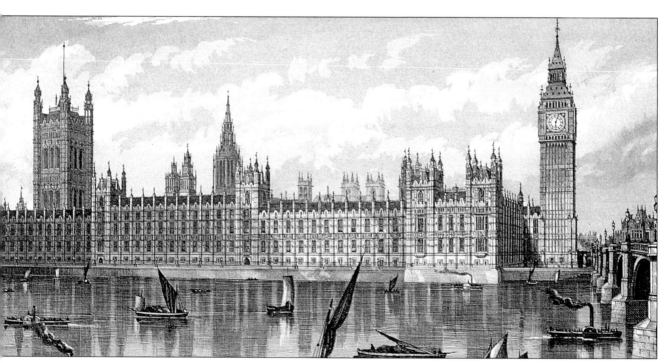

The Houses of Parliament, 1837–67, Sir Charles Barry (1795–1860) and Augustus W. N. Pugin (1812–52).

The original Houses of Parliament in London was destroyed by fire in 1834. A competition was held to design a new one. This design by Barry and Pugin won. Using modern materials, they included medieval details which were used in the Gothic Revival. It has become one of London's most famous landmarks.

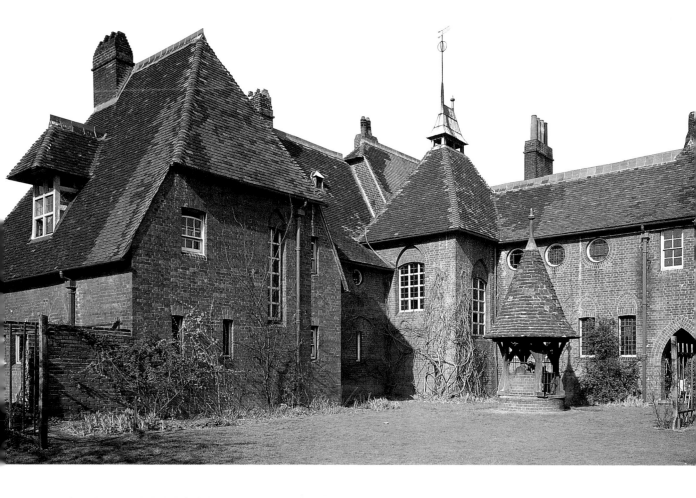

The Red House, Bexleyheath, Kent, 1860, Philip Webb (1831–1915).

This house, designed for William Morris and his wife, is named after the red bricks it is made of. Outside no two walls are the same. Inside it is large and airy. Its pointed arches come from the Gothic Revival and the Middle Ages. Webb designed both the inside and outside of the house. Like other Arts and Crafts designers, he believed that good design should be timeless and enjoyed by everyone.

Arts and Crafts architecture

The Arts and Crafts designers were fascinated with the architecture of the Middle Ages, as well as the other arts of the period. Philip Webb, who was in the movement, designed furniture, metalwork, glass and **tapestries** with William Morris, but he was actually an **architect**.

New ideas

Many rich Victorians had grand, heavily decorated houses built to show off their wealth. Some architects believed that decoration for its own sake was a waste of time. Richard Norman Shaw (1831–1912) designed plainer houses, moving away from the more complicated Gothic style. Any decoration had a use.

IRON AND GLASS

In 1851 a Great Exhibition was held in London to celebrate the achievements of British and foreign industry. Prince Albert wanted the exhibition building to be in Hyde Park. Because the exhibition was temporary the building had to be easy to take down. Two hundred and forty-five designs were turned down — the finished buildings would have been too solid and would have damaged the park.

A giant greenhouse

A gardener, Joseph Paxton, asked if he could try to do a design. Based on methods he had used for glasshouses, his design was made of glass, iron and wood. This giant greenhouse was accepted. The building became known as the Crystal Palace.

The Crystal Palace, 1851, Joseph Paxton (1801–65).

Paxton had already designed a glasshouse for rare plants. The design for the Crystal Palace was based on the structure of a lily pad. Paxton convinced people that lily pads were strong by floating his 7 year old daughter on one.

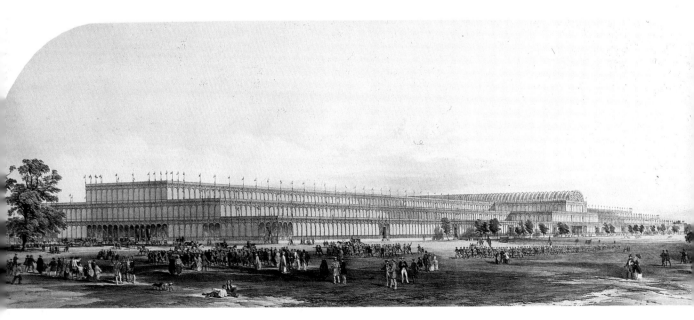

How the Crystal Palace was built

The Crystal Palace was 563 metres long, 122 metres wide and 18 metres high. The original design was changed to fit around the trees on the site. The building of the Palace was cheap and easy. The latest steam machinery and **mass production** methods were used. By 1851, glass was being mass produced in one-sized sheets.

The Crystal Palace used 300,000 glass sheets to let in as much light as possible. Once it had arrived, trolleys were used to carry the glass to the right places for the building. Iron was also cheap. Strong and easy to put together, the building took less than six months to complete.

Charles Rennie Mackintosh (1868–1928)

About fifty years after the Great Exhibition, a Scottish **architect** and designer used metal and glass in some of the best Art Nouveau buildings and furniture in Britain. Mackintosh simplified and **stylized** natural forms with a fresh, original touch.

Glasgow School of Art, 1897, Charles R. Mackintosh (1868–1928).

Mackintosh won a design competition for this building. Balanced and light-filled, it featured tall windows, soft colours and elegant proportions.

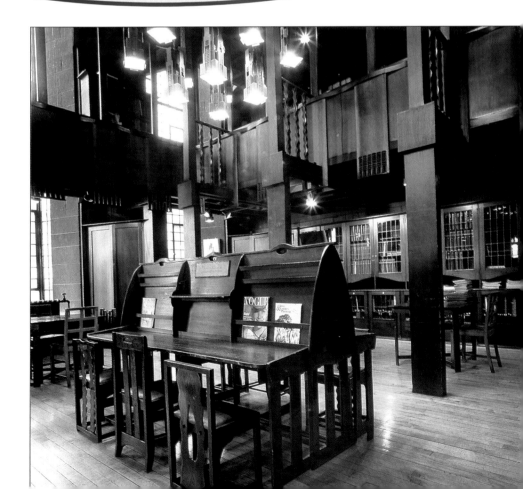

COMMERCIAL ART

In the 1840s special design schools opened to train artists as designers. **Commercial art** became a new industry.

Advertising art

Also in the 1840s, cheaper methods of printing became available and **mass produced** goods were sold under brand names for the first time. This led companies to do more advertising. Artists discovered a new way to earn money – through advertising design. Even famous and well established artists did advertising work.

Magazine art

Stories by great writers such as Charles Dickens were **serialized** in magazines. Artists illustrated each part. Later, the stories were printed as illustrated books. Colourful picture books for children were also popular. Victorian artists also produced the first greetings cards.

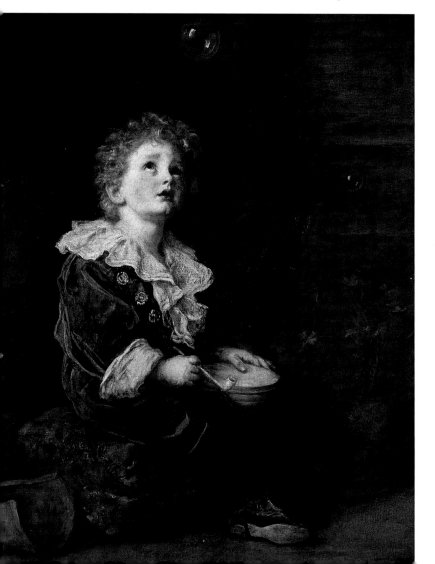

Bubbles, 1886, Sir John E. Millais (1829–96), oil on canvas.

Oil paintings could be printed clearly by chromolithography – a process which uses a separate plate to print each colour, so the picture is built up, layer by layer. A painting of a little boy by Millais, the Pre-Raphaelite, was bought by Pears and used to advertise their soap.

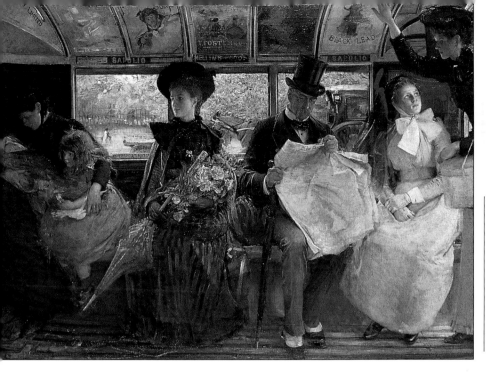

The Bayswater Omnibus, 1895, George William Joy (1844–1925), 122.5 x 175.2 cm, oil on canvas.

The **composition** *makes you feel as if you are in the bus, too. Advertising was seen by many different travellers. This new art brightened up public places.*

Make your own Victorian pop-up

Materials: paper, scissors, glue, pencil, felt–tipped pens or paints.

1 Fold two pieces of A4 paper in half. Put one aside. Fold the other paper again, into quarters, then open it so it is in half again.

2 Unfold these corners and fold the paper back once again into quarters. Cut a curve from the top-fold edge to the diagonal crease line.

3 When you open the sheet out, the triangular petals will stand out.

Fold the top corners of each side into the centre crease line. Unfold these corners, turn the paper over and fold down the corners on this side, too.

Open the paper so it is in half again and push the triangle shapes inwards.

Draw other petals around them. Glue the other piece of paper to the back of the sheet, but not to your pop-up petals. Decorate your card.

TIMELINE

1837	Victoria is crowned Queen.
	Charles Dickens' *Oliver Twist* is published.
1837–67	The Houses of Parliament, designed by Barry and Pugin, is built in London.
1839	William Henry Fox Talbot invents a way to print photographs on paper.
1840	Queen Victoria marries Prince Albert.
	The Penny Post is introduced.
1844	Turner paints Rain, Steam and Speed.
1848	The Pre-Raphaelite Brotherhood is founded.
1851	Paxton's Crystal Palace is built in Hyde Park for the Great Exhibition.
1854–6	The Crimean War.
1859–60	Philip Webb designs and builds the Red House.
1861	Prince Albert dies of cholera. William Morris starts 'The Firm' of Arts and Crafts designers.
1863	The world's first underground railway system opens in London.
1870	The Education Act provides schools for all children.
1874	Whistler's Nocturne in Black and Gold provokes outrage.
1876	The first telephone.
1879	Thomas Edison perfects the light bulb.
1880	Burne-Jones designs 'The Pelican'.
1885	Benz and Daimler make the first motor cars.
1886	Millais sells his painting of a little boy to Pears to be printed as a poster.
1887	Queen Victoria's Golden Jubilee (fifty years as queen).
1895	G. W. Joy paints The Bayswater Omnibus by hiring a real bus and using friends and family as models.
1897	Queen Victoria's Diamond Jubilee.
	Mackintosh's design for the Glasgow School of Art is accepted.
1901	Queen Victoria dies.

1835
1840
1845
1850
1855
1860
1865
1870
1875
1880
1885
1890
1895
1900

GLOSSARY

architect someone who designs a building and makes sure that it is properly built

asymmetrical Not the same on both sides. Different on one side to the other.

bronze a brownish-gold metal made from a mixture of copper and tin. It is hard wearing and easy to work with.

cast a sculpture produced from a mould

commercial art art to be sold to many people; usually printed works, like posters

composition the way things are arranged in a picture, so that the finished layout does not look a jumble

critics people who make a living by judging art

enamelled coated with a glass-like substance

genre the word means 'type' or 'style'. Victorian genre paintings were the type that showed scenes from everyday life.

gilt-bronze a gold–like metal, thinly coated over bronze

glycerine a thick, clear, sticky liquid first obtained from soap making

guilds groups of craftsmen who follow the same craft. Guilds have rules that members have to follow.

gum a sticky substance inside a plant. When mixed with pigment it sticks to the surface of the painting and dries hard.

illustration a drawing or painting usually made for a book or magazine

Impressionists the name given to a group of painters who worked at the end of the 19th century. They recorded the effects of light, colour and fleeting moments by painting pictures with pure, bright colours.

landscape a painting of the countryside

marble a rock that can be polished to a brilliant shine and is good for carving. It comes in many colours, but white has usually been the favourite.

mass produced many goods made at once, all the same size and shape

Middle Ages a term used to describe the period between 1066 and 1500

oil paints/oils paints made by mixing pigment with vegetable oil into a thick paste. Oil paint dries slowly so artists can correct their work.

oil sketches quick paintings in oil paints

patrons people who buy or commission artists' works

pigment coloured minerals or chemicals that give paint its colour

plaster a fine white powder made from a rock called gypsum. It sets hard after it is mixed with water and left to dry.

portraits pictures or statues of a real person or animal

serialized broken into parts, and continued at regular intervals.

stylised when the picture of an object is exaggerated or simplified

tapestry wall-covering picture made by weaving wool or silk

watercolours paints made with pigment mixed with gum, and diluted with water

zinc bluish-white metal

INDEX

Numbers in plain type (24) refer to the text.
Numbers in bold type (**28**) refer to an illustration